HUNDERTWASSER

This catalogue was first published on the
event of the Hundertwasser Exhibitions
in New Zealand and Australia 1973

HUNDERTWASSER'S

COMPLETE GRAPHIC WORK 1951-1976

We should realize our own dreams
Draw on our creative ability
Independently and unwaveringly realize our ideas
in our daily lives.

My heartfelt thanks go to PRESTEL Verlag
and to Jürgen Krieger and his team for their
assistance in publishing a new edition of
this magical volume by Hundertwasser.
A gift to mark Hundertwasser's 80th birthday,
it's a real collector's item for book lovers.

In 1973, Hundertwasser embarked on an
exhibition tour to museums in Australia and New
Zealand. To accompany this tour he wanted to
publish a catalogue small enough to be carried
in a handbag or jacket pocket like a much-loved
treasure. It was to be a book with 98 high-
quality reproductions – using six special colours
in addition to the usual four colours – together
with gold and silver, and metal embossing in nine
colours. It was to have a hard cover designed by
Hundertwasser, with red sewn binding, rounded
corners and black edges, and to be set in

Souvenir and in the »Regentagschrift« font Hundertwasser himself had designed.

But no publishing house was prepared to produce and publish the catalogue-booklet according to Hundertwasser's exacting standards. They were adamant that his specifications and production requirements ran counter to business experience and market conditions, and that the book would be impossible to sell because of the high production costs.

So I decided to produce it myself, exactly as Hundertwasser had imagined it, although this was completely at odds with all the market rules, as the publishers explained to me so persuasively. Because Hundertwasser promised me that people would fall in love with it all the same. How right he was! More than 750,000 copies have sold in eighteen editions through exhibitions and through direct sales, without sales representatives, without a sales organization, and without a publisher. In 1983 I decided not to produce any further editions, although demand was still very lively.

The spirit of the book and its magical charm have remained as fresh as ever. It was the first book Hundertwasser designed down to the last detail, and it was followed by others

1973 hatte Hundertwasser eine Ausstellungs-Tournee in Museen in Australien und Neuseeland. Er wollte begleitend dazu ein kleines Buch, das man in der Handtasche oder im Sakko mitnehmen kann wie einen geliebten Schatz. Ein Buch mit 98 Farbreproduktionen in den vier Skalafarben und sechs weiteren Farben, Gold und Silber, Metallprägefolien in 9 Farben, mit einem von Hundertwasser entworfenen Hardcover, mit roter Fadenheftung, abgerundeten Buchecken und geschwärztem Schnitt, gesetzt in Souvenir als auch in der von Hundertwasser entworfenen »Regentagschrift«.

Kein Verlag war bereit, das Katalogbuch, wie
Hundertwasser es wollte, zu produzieren und zu
verlegen. Es verstoße in seiner Ausstattung und
Produktion gegen alle Erfahrungswerte und
Marktgegebenheiten und wäre auf Grund der
Produktionskosten unverkäuflich.

Ich entschloss mich, es selbst zu produzieren,
so wie Hundertwasser es sich vorstellte, obwohl
es allen Regeln des Marktes, wie mir von den
Verlegern überzeugend dargelegt wurde, diametral
entgegen stand. Denn Hundertwasser versprach
mir, es würde die Gegenliebe der Menschen finden.
Wie Recht er hatte! Über 750.000 Exemplare in
18 Auflagen wurden in Ausstellungen und im
Direktverkauf abgesetzt, ohne Vertreter, ohne
Vertrieb und ohne einen Verlag. 1983 entschloss
ich mich, weitere Auflagen einzustellen, obwohl die
Nachfrage noch sehr lebendig war. Der Geist des
Buchwerkes und sein Zauber sind erhalten und
lebendig geblieben. Es war das erste von Hundert-
wasser in jedem Detail konzipierte und gestaltete
Buch, dem weitere folgten.

Joram Harel
Wien, 2008

HUNDERTWASSER
by Walter Koschatzky
Director of the Albertina State Collection of Graphic Art, Vienna

Friedensreich Hundertwasser is outstanding among the postwar generation of Austrian artists. Scarred by the dangers, burdens and sufferings of their childhood, they were suddenly overrun after 1945 by a world from which they had been isolated in their formative years. Instead of going through an organic process of evolution, this generation was in danger of becoming mere imitators. In the end, however they won through, found their identity and started to send out their own message 🔳

Born in Vienna in 1928, Hundertwasser gave early proof of this talent. Until 1948 he painted landscapes, flowers and nature in general. He also showed skill as a portrait-painter 🔳

Aged twenty, he first encountered the œuvre of Egon Schiele who had died in his prime in 1918. Schiele's influence proved decisive. Study at the Academy disappointed Hundertwasser and he

ran away to Italy. There he met the young French painter René Brô who was wandering through Italy with a group of artists. He joined their company and became acquainted with the avant-garde programme of the Ecole de Paris. He did not, however, fully imbibe their philosophy. On the contrary, he matured to a style of his own 🖿

Thereafter he travelled widely. In North Africa he fell in love with Arabian music and sought a way of life that began to shape not only his painting but also his basic outlook. In Paris he lived in dire poverty. Yet he considers this ex-perience one of the most important periods in his life. Without abandoning his own convictions, he drew great inspiration from the abstract movement which was then in full bloom. It was in those years that the spiral as a symbol came to birth, and from there on to this day this con-figuration continued to fire his imagination 🖿

He was quick to foresee the end of Tachism. In 1954 he evolved a theory of his own which he called »transautomatism«. He introduced it with the words: »Every one of us has the duty to be creative; it is our only weapon against the new

illiteracy.« This became the focal point of his philosophy. To him, art was no longer a purely aesthetic game. The artist carries too much responsibility to shrug off the ignorance of the masses with a resigned »l'art pour l'art«: he has a very definite part to play in mobilising the creative forces in an increasingly shallow consumers' society with its cheap allurements, indolence and passivity. Hundertwasser grew to be convinced that cities with their so called »modern« architecture destroy man by breaking his individuality. He calls the straight line »godless«, inhuman. Lines should unfold freely and take their own course; men should be free to invent their own dwellings or at least to adapt them. The spiral must be free: vegetative, not geometrical and not final, by no means a mere ornament without meaning or message 🔳

Opening his first exhibition in the Vienna Art Club in 1952, Hundertwasser said: »I want to be independent of the gigantic bluff of our civilisation.« This was his first public protest, his first warning: others followed – some caused scandals. They all pilloried rot and disintegration – but he did not stop there. He advocated new ways of

creativity in a better, i. e. freer, world. In 1956 he promulgated his »Grammar of Looking« (»Die Grammatik des Sehens«), a manifesto of man's right to develop his individual creative impulses 🔲

This led to the final break with traditional »l'art pour l'art« mentality. The artist must work for society as a whole, not just for the elite, the happy few; he must not just contemplate but help change the world. Let others destroy, develop critical consciousness as a lever for change, formulate anti-art, preach revolution: Hundertwasser sets out to create the image of a future in which life becomes more dignified, in which he can put his faith, in which his poetic imagination and his respect for the dignity of man can unfold 🔲

His wanderlust continues. He loves to sail the seas; now he can afford to roam the Mediterranean in his own boat, an old converted trawler; he calls her »Rainy Day« (»Regentag«). Meanwhile his works are getting known; galleries begin to take him up, collectors to buy his work, there are exhibitions in numerous countries 🔲

He became famous mostly through his graphic art, though he denies that drawings are genuine works of art – »one always has to work in a team, use machines, employ printers and seek technological perfection, ... enough to give you gastric ulcers«. The discovery of the possibilities of colour lithography fascinates him, and it is in this medium that he found perfection, Then comes silk-screen printing; this technique he finds in Venice. In Japan, he makes another great discovery: the ancient Far-Eastern art of polychrome woodcuts, threatened by extinction. For more than ten years he works on his series »Midori-No-Namida« – a new inspiration 🔳

Hundertwasser's paintings are intensive in their colours and delicate in their balance: lyrical and sensitive. Their meanings is often veiled, sometimes not easily understood except in emotional associations, not obtrusively tendencious. Still, is it not a mark of real accomplishment to hint rather than to point, not to give away your message too cheaply 🔳

Today Hundertwasser has many admirers; of course some people reject him. However, this

speaks for him, for to please everyone's taste is by no means a mark of distinction 🖼

I for one believe that one can really love his pictures just as one can fall in love with precious stones – look at them and enjoy them. His art can do more than just please: it stimulates thinking, dreaming and deciding to take action in the world 🖼

Hundertwasser has become one of the most important Austrian artists since 1945. I would readily count him among the most famous artists of our time 🖼

This is why I also give my full blessing to the original idea of commissioning him do design a new Austrian postage stamp. This stamp will carry all over the globe the message that our postwar generation speaks out for us 🖼

His avowed aims reach further: He demands the humanisation of our environment: this is why he paints houses overgrown with greenery and design models of motor highways which merge into the countryside 🖼

All power to his brush: not just success for him, but a boon for all of us 🖼🖼🖼🖼🖼🖼🖼🖼

HUNDERTWASSER

COMPLETE GRAPHIC
WORK 1951-1976

THE PROPHET

Hundertwasser appears sometimes in public dressed in what might be called "strange ways". He could, for instance, walk into the dining room of Claridge's in London wearing on each foot knitted socks of different colors which are covered by a combination of sandals and shoes fashioned by himself, a multicoloured sailor's cap on his head, a striped caftan over his shoulders and yet, not one person present will laugh or even snicker. Somehow, they feel very stongly that a mysterious, important messenger has entered the room.

What true artists say or create is always ahead of their time. Eventually they are understood by more or less everybody, but a whole generation may have passed. Pronouncements which may have been completely alien to accepted notions become the norm. What looks strange, or possibly even revolting, transforms itself into a thing of vibrant beauty. This anticipation of later events can truly be called prophetic.

What we read in today's papers about ecology, about the preservation of nature in its purest form, about proposed changes in architecture,

about urban development, all these ideas were not only well-formed, but fervently advocated by Hundertwasser as far back as a quarter-century ago.

Hundertwasser was blessed with a mother who understood from the very beginning. An extremely talented painter herself, she recognized the genius and the wisdom of her son at an early age, and encouraged and furthered its development, thereby making the most important individual contribution towards the path of his realization.

Like other prophets, Hundertwasser always had his disciples who would follow him and listen, and then carry the message even to the farthest parts of the world. Now the world has understood. It was the Youth, with whom Hundertwasser has a special bond and communion of thought and feeling, who carried the banner which is now flying over the Museum of Modern Art in Paris.

This museum is presently showing Matisse and Torres Garcia on the upper floor and Hundertwasser in the magnificent spacious exhibition rooms of the lower level. While there are very few people for Matisse and, unfortunately, practi-

cally nobody for Torres Garcia, the Hundert-
wasser exhibition is overflowing with visitors.
I mention this not as a point of reference regard-
ing artistic values, but only to underline
the immense popular interest for the great
colorist of the second part of the twentieth
century. In spite of the multitude there was
absolute silence. One could have heard a needle
drop. It was the kind of reverence usually
reserved for a place of worship.
I walked from room to room in the company of
Fernando Botero. We were both overwhelmed
by what we saw and certain to witness one of
the most beautiful and important manifestations
of artistic creativity of our time. We passed from
paintings to graphics, from Gobelins to archi-
tectural models. We not only marvelled at the
past and admired the present, but strongly felt
the great promise of the future.
Hundertwasser had redeemed his prophecies
and will go on making new ones as long as God
will give him the strength to work.

JOACHIM JEAN ABERBACH
New York, October, 1975

HUNDERTWASSER ON GRAPHIC ART

True, works of graphic art are something vastly
more difficult. Graphic art is not a direct art,
straightforward like painting.
When you paint a picture you sit down in your
room and paint and it is nobody's business
when the painting will be finished.
You can put the colours onto the paper just
as you imagine. There is the paint, there is the
paper, as simple as all that. But everything
concerning the printed work is muchmore
complicated and somehow emotionally worrying –
because you are not alone, you have to work
with a team, with many people, with machines,
printers and other technicians. Even sales
and distributions are more complicated than
in the case of paintings.
It is really a great mental and physical strain
to produce printed art.
Unfortunately you cannot simply paint on the
paper on which your printed work finally appears.
You have to paint, draw, incise or cut on
different materials.

On the stone or zink sheet from which the print
is pulled off, on a screen or mesh through
which the paint is pressed, on transparent foil
from which the drawing is transferred, you have
 to use blue paper to copy outlines, you have to
paint, draw or incise on copper and to cut into
linol and wood.
And the printed result is never quite what you imagine.
It is a surprise. It is an art around the corner.
What can you expect around the corner?
The great advantage of printed art is of course that
it can be reproduced many times and can be made
available, to many people.
Obviously it is important that art should reach large
groups of the population but I do not always receive
thanks. People are against it or envious.
So to say to produce graphic art is an occupation
which causes stomach ulcers.
It is an unnatural activity.
Imagine you have to throw a potato against a certain
spot onto a wall in front of you.
You can see your goal in front of you, you can aim
accordingly and you can see clearly where the
potato hits the wall.
This is our world.

But, in the world of printed matters
your potatoe will not mark the spot on the wall
in front of you at which you have aimed
but will hit some other totally unexpected place,
for instance the wall behind your back.
But if you throw backwards you will hit an unknown
spot in front of you.
If you have aimed not high enough on the wall
in front of you and if consequently you want to hit
a spot a little lower behind you you must aim
upwards in front of you.
Not only you have to inverse your sides like in a
mirror-writing, you also must imagine your picture
upside down with lateral deflections
and in the negative.
If you want a result in red you must paint in green,
white must be done in black.
And if you want a great many colours one on top
of the other in a multicolour print you must paint
each layer in black and imagine the colours.
This is why creations in printed art are so unnatural
and frustrating.
It is like playing simultaneous games with many
unknown tricky partners who know the rules while
you can just imagine them.

EYEBALANCE NUMBER FIVE

I worked with a FARMER when I
saw how brown the EARTH is
and how green the GRASS
So I decided to become a painter

1946 Schwanenstadt

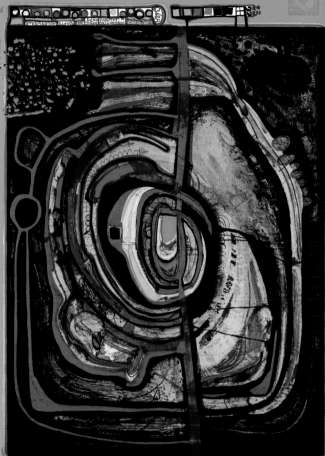

470A **1971**

RELATIONS OF A SPIDER

蜘
蛛
の
関
係

GOD came to EARTH
twice in this Century

In occasion of the absolute
naturalism about 1900 and
in occasion of the absolute automatism
(Action Painting Time about 1950)

We touched heaven twice
and got burned,
but in the Churches and in
the Parties-Central-Committees
they have not been aware of it
 1955 Milano

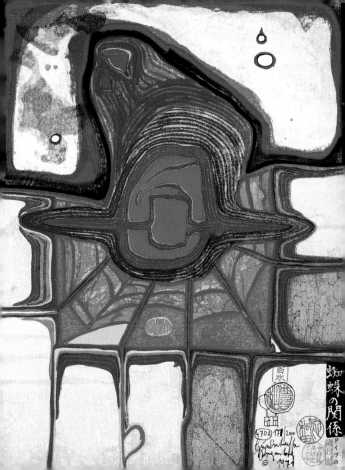

 475A

1972

RAIN OF BLOOD IS FALLING
INTO THE GARDEN

The first RAIN DROPS give us

a divine lesson

May they fall upon your face

on the sidewalk

or into GRASS

1952 Wien

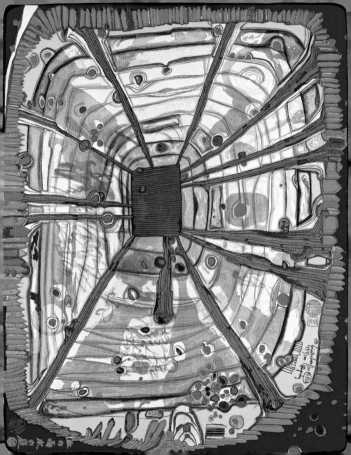

LITTLE PALACE OF ILLNESS

小
城
の
美
の
病
院

The transparent winter trees
frozen to glass
I took from
Walter Kampmann in 1948
(who died 1945 in Berlin)

Then I made an exchange deal
with RENÉ BRÔ who painted
round BRÔ-Faces with almond-shaped
eyes put high up to the brain
We gave each other the right to paint
Kampmann-TREES and BRÔ-Faces

1949 Paris

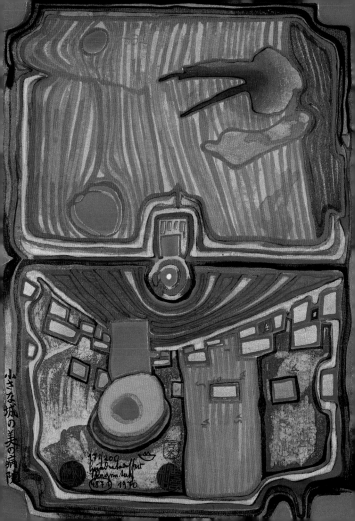

1967

SPIRAL SUN AND MOON HOUSE
THE NEIGHBOURS

The Lines I trace with my FEET
WALKING to the Museum
are more important than the lines
I find there hung up on the walls
 1953 Paris

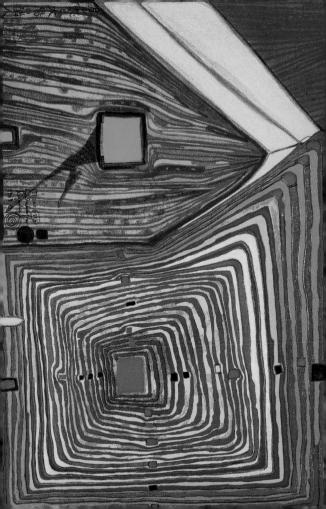

STREET FOR SURVIVERS

La ligne droite conduit à la perte de l'humanité

The straight line leads to hell

1953 Paris

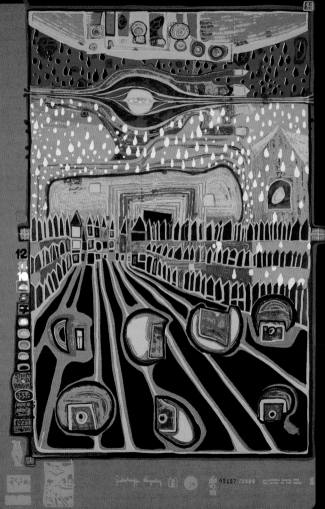

563A **1968**

SPECTACLES IN THE SMALL FACE

**The first signed specimen of the
»Spectacles in the small face« was
stolen out of a Munich Gallery in 1969
It is signed on the left side. The finder
is kindly asked to return it to me**

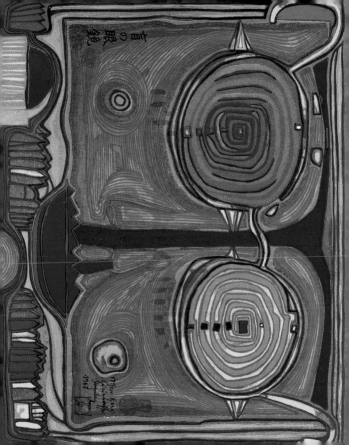

SUNSET

落
陽

Our illiteracy is
our inability to CREATE

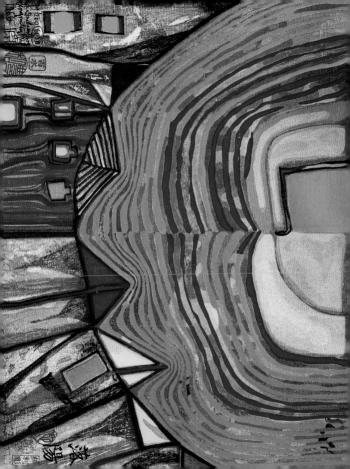

630A 1971

IT HURTS TO WAIT WITH LOVE
IF LOVE IS SOMEWHERE ELSE

We live in PARADISE
but we do not know it

Do not destroy
Do not revolt
Do not escape
Just IMPROVE slowly
And all will be good

WAITING HOUSES

The only free Architecture we still
have are the self made houses
of some surviving PARADISE people

1958 Seckau

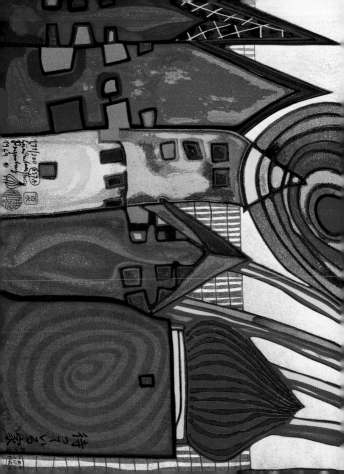

EXODUS INTO SPACE

Only when the Trinity consistant of
ARCHITECT, BRICKLAYER
and INHABITANT
is one Person or one Unity
the house they build is a living architectu

This Trinity
ARCHITECT, BRICKLAYER, INHABITANT
is equal to the Trinity
God Father - God Son - Holy Spirit

If they get separated
their architecture becomes crime

1958 Seckau

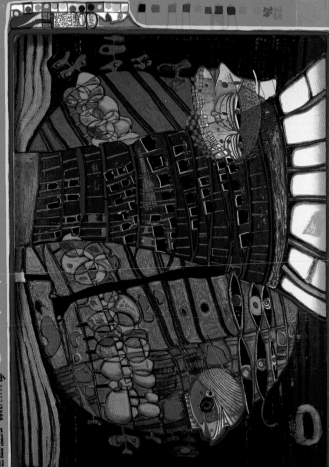

 1971

A RAINY DAY ON THE REGENTAG

»Fensterrecht« means everyone's right
to CREATE his OUTSIDE WINDOW-WALL
as far as he can reach
so that one can see from far away:
There lives a Man

1972 Düsseldorf
1958 Seckau

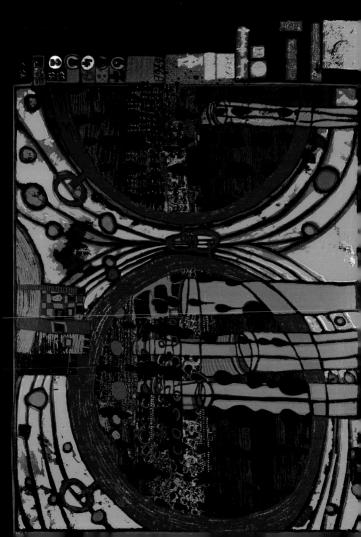

 1969

GOOD MORNING CITY

»WE ARE CONDEMNED TO BEAUTY«

This told me VARDA

the King of Sausalito in 1968

BLEEDING TOWN HUNDERTWASSER 686

1970

GOOD MORNING CITY–
BLEEDING TOWN

Phosphor Version

My Eyes are tired

 1957 Vienna

Hundertwasser is a gift to Germany

 1964 Köln

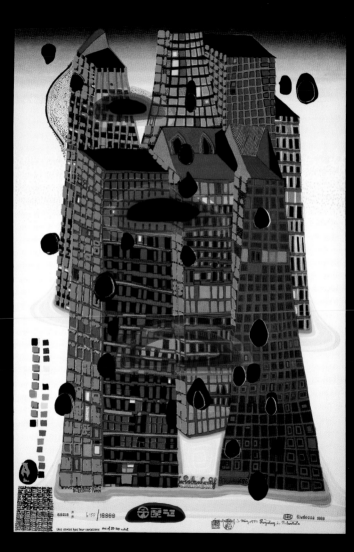

COLUMBUS RAINY DAY IN INDIA

Holy Words to be written in Capitals.

PLANTS TREE-DUTY
GREEN COLOUR
ARCADES NATURE
RAINDROPS GREEN POWER
GRASS SHIT
RAIN GARBAGE
WOODLANDS EARTH
VALLEYS VEGETATION
TREES CREATIVITY
HORIZON RIVERS
SNOW WATER
WINDOW-RIGHT PARADISE
SEA FARMER
SAILBOAT MEADOWS
WIND AND WATER MILLS AIR
HEDGES GARDEN
HANDMADE NUDITY
POND TO WALK
LAKE BYCYCLE

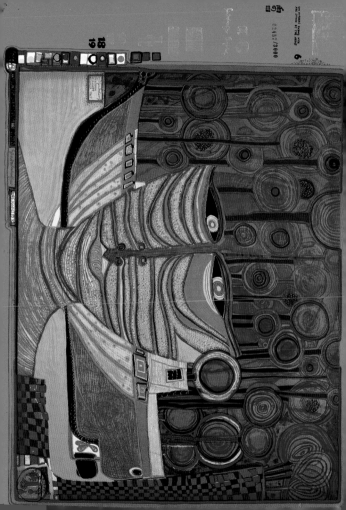

 1971

TWO TREES ON BOARD
OF THE REGENTAG

The relation TREE-MAN

must become religious

Only when you will love the TREE

like yourself

 you will survive

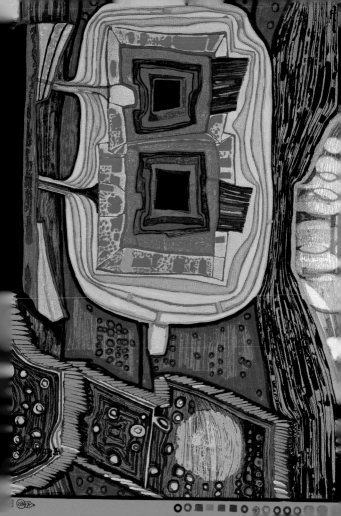

GREEN POWER

The HORIZONTAL belongs to NATURE
The vertical belongs to man

That means:
Where SNOW and RAIN falls
VEGETATION should grow in the cities

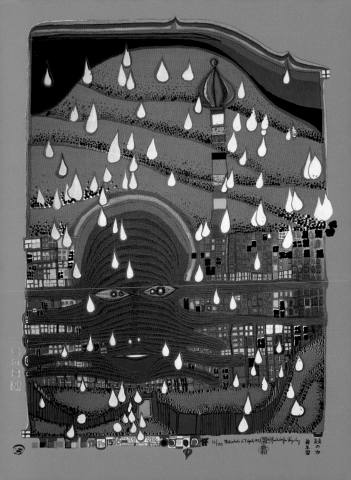

RINALAND OVER THE BALCANS

Egon SCHIELE ✳ ✳ PAOLO UCCELLO
Walter KAMPMANN TREES ✳ ✳ IKONS
SONNENSTERN ✳ ETRUSCAN MURALS
Pieter BRUEGHEL ✳ ✳ Josef PICKETT
ROUSSEAU ✳ HIROSHIGE ✳ ✳ KLEE
MAORI ART ✳ CHINESE LANDSCAPES
VAN GOGH ✳ THE SCHOOL OF SIENA
Arnulf RAINER ✳ Elsa STOWASSER
ABORIGINAL CAVE PAINTINGS ✳ BRÔ
GIOTTO ✳ KUNIJOSHI ✳ ✳ BRAUER
Gustav KLIMT ✳ ✳ ✳ Jerome BOSCH
HOKUSAI ✳ ✳ PERSIAN MINIATURES
JANSSEN ✳ ✳ ✳ HUNDERTWASSER
NAIVE PAINTINGS ✳ FRA ANGELICO
early LEHMDEN ✳ ✳ ✳ ✳ early FUCHS
INDIAN MINIATURES ✳ ✳ HAUSNER
MUNCH ✳ GAUGUIN ✳ PEYRONNET

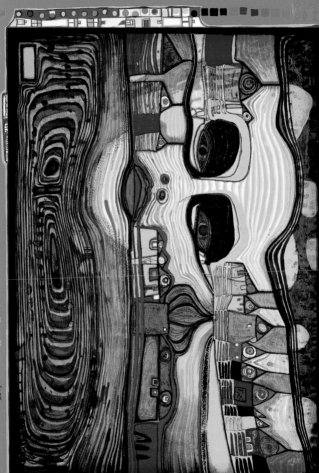

1971

THE RAIN FALLS FAR FROM US

Only when the DIVINE respect of
GREEN POWER, only when the love
of VEGETATION becomes part
of us all, only then we can improve
step by step our dying environment

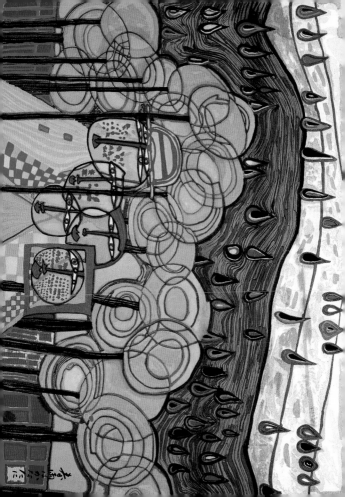

696A

LAST WILL IN YELLOW

DIE GERADE LINIE IST GOTTLOS
The straight line is Godless
The straight line is the only
non-CREATIVE line
The straight line does not suit man
as the image of God

1958 Seckau

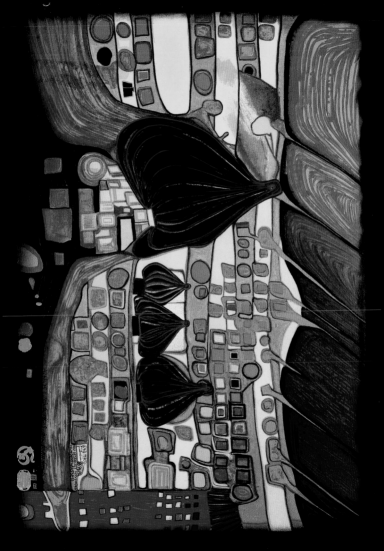

 1971

REGENTAG ON WAVES OF LOVE

Never step into a sterile building
where the walls are flat and the
windows are all the same
Such house will bring big harm to you
If you are visiting someone in such
a house: boycott it
If you are not allowed to transform it:
stay outside and ask the person
you want to visit to come out
Because it is a prisoner's house

 1968 Vienna

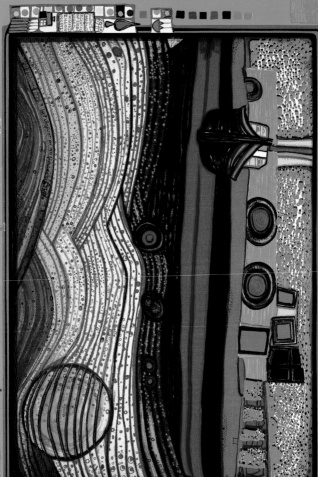

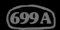 **1971**

THE HOUSES ARE HANGING
UNDERNEATH THE MEADOWS

The roofs must become WOODLANDS

The streets must become
GREEN VALLEYS

The traffic should pass under ARCADES

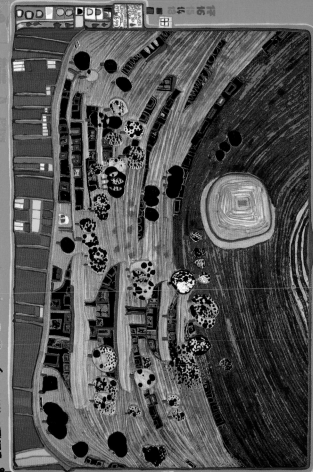

Olympic GAMES GRAPHIC MUNICH

**First Stage. © by Edition Olympia
1972 GmbH München**

This was a huge Mirror
It fell and broke to pieces
My mother was upset. I conforted her:
»Please Mother do not cry
I will make something out of it a hundred
times more precious than the mirror«

Then on a cold winter evening
with deep snow in the streets
I listened to a football game
on the radio: Austria against England
It was then called the
»Match of the Century«
So I decided to paint a football game
on the wooden Mirror frame

 1953 Vienna

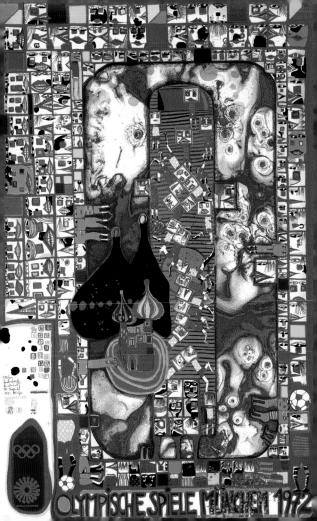

OLYMPISCHE SPIELE MÜNCHEN 1972

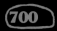

OLYMPIC GAMES POSTER MUNICH

Second Stage. © by Edition Olympia
1972 GmbH München

About some years ago when I drove
from Vienna to Paris I got lost in Mun
I passed an abandoned field
and saw a HANDMADE Russian Churc
so beautiful so that I stopped
and made a foto
Later I learned that the abandoned fie
was chosen to be the Olympic Arenas
The architects wanted to
chase away the nice Russian Pope
Timofej and to distroy his church
But the People of Munich protested
and protected Timofej
I decided to transform my 1953
Football Game into an Olympic poster
and put Timofej's HANDMADE Church
into it

1971 Munich

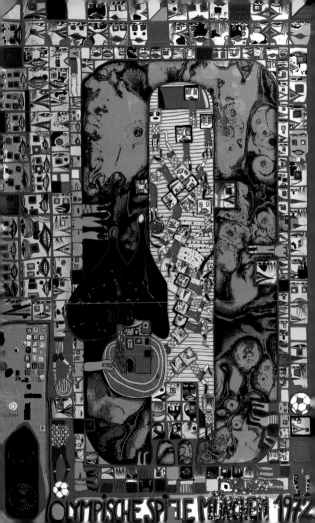

OLYMPISCHE SPIELE MÜNCHEN 1972

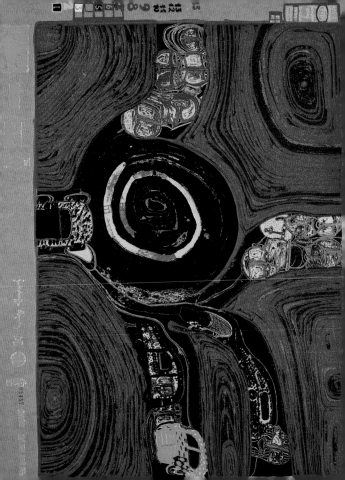

ONE OF FIVE SEAMEN

NO RELIGION
NO SOCIALISM
NO DOGMATISM
BRINGS US CLOSE TO PARADISE
ONLY CREATIVITY DOES

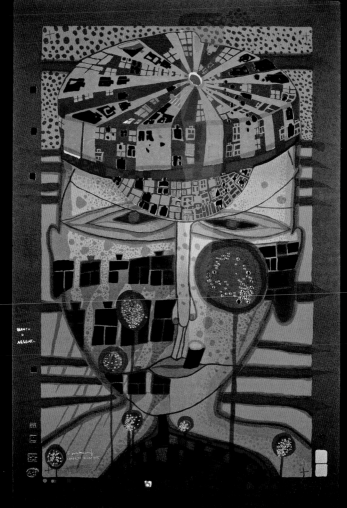

WIELAND SCHMIED:
HUNDERTWASSER EN ROUTE
TO NEW ZEALAND

The exhibition of his works in the
museums of New Zealand and Aus-
tralia is an event of special signifi-
cance for Hundertwasser 👁
Of all places in the world, the
idea of New Zealand represents for
him something like a last earthly
paradise: a place as yet unmarked by
the mutilations and ugliness of civili-
zation, of the over-industrialization of
the Western world which elsewhere
has brought in its wake polluted water,
a poisoned atmosphere, ravaged
forests; a place which has not yet seen
the decline of good craftsmanship and
appreciation of individual achieve-
ment, nor experienced the maladies of
the human psyche mounting up at the
same rate as the storeys of modern
skyscrapers 👁

Thus New Zealand seems to him to
offer the possibility of a life which is

still essentially natural, and for Hundertwasser natural life is synonymous with creative life ❧

He sees embodied in New Zealand his Utopia of a sound and harmonious existence, granting to each individual the opportunity of discovering his inherent talents and of developing them in a meaningful way, free from all constraint ❧

The image of New Zealand as a land of unspoilt nature has influenced Hundertwasser's painting ❧ When he paints he dreams of eternally-green islands of peace ❧ The more environmental pollution and the destruction of the earth's primeval resources have increased in recent years, the more important has become to Hundertwasser his image of a region where these afflictions are still unknown ❧

So it is that Hundertwasser has, in his paintings, long been on his way to this country: now the occasion of his exhibition will fulfil his dream by giving him the opportunity of experiencing it

in reality ⟨?⟩ For he himself and his work to be accepted by the people of New Zealand as belonging to them would mean more to him than any success, no matter how spectacular, in the great centres of the art-world, in New York, London or Paris ⟨?⟩

Hundertwasser's vision of a humanely-natural world, dreamed by a »painter of pure heart« (as he was called even early in his career) is by no means a secondary interest, occupying the artist only on the periphery ⟨?⟩ It is, on the contrary, right at the heart of his work, it is both the source and the goal of his artistic production; it dominates his thought and action as it determines content, form, colour and technique in his painting ⟨?⟩

The themes of Hundertwasser's pictures are labyrinthine architectural structures, hill-like houses surrounded by protecting fences, house-like steamers surrounded by protecting waves, leaf-like windows surrounded by protecting spirals, the spirals running

inwards with many convolutions like paths leading towards a cave of security ◉ On the roofs of his buildings, often skyscrapers with storey grown upon storey, crooked, rain-soaked and weatherbeaten, there is grass sprouting, trees and meadows are growing, nature has returned. Nature as a building, landscape as a building, the mountain as a building, the tree as a building: this is one of the basic motives of Hundertwasser's painting ◉ From the beginning, the spirit of his pictures beautifully translates into reality the demands which Hundertwasser made emphatically time after time in his Architecture Manifestos for an individual, non-uniform, non-conformist Architecture ◉

Even the individual forms of his paintings are organically determined-such forced constructions as the straight line and the right angle are foreign to them ◉ Hundertwasser's forms are rooted in the fullness of exuberant Baroque, they are derived from the ornamental richness of the

Jugendstil, an art which always related itself to living forms and hence to nature ◎ In the Jugendstil it was the stylised waves, the long, sensitive undulations which fascinated him, and their origins in the many diverse images of growth, in algae, lianas, rushes, creeping plants and water-lilies, which appealed to him ◎ Following an organic structural plan, individual lines and strips of colour merge into irregularly-curved forms, allegories of plant-life ◎

Hundertwasser's favourite colour is green. Green, he maintains, should be everywhere; in meadows and on roofs, in the water and on mountains. His eye can perceive the most diverse shadings of green, from Schweinfurt green to the green of mildew and of verdigris ◎ Grass is green and islands are green, the foliage of trees and floods of rain, eyes and clouds can be green, ponds and windows, the beard of a bald man and the head of the three-eyed Buddha, the Indian jungle and Venetian flowers, the Little Palace of Disease and the

Three Houses of Atlantis, his steamers and his spirals ✪ Besides green he loves the brown of Pozzuoli earth and the ochre of burnt sienna, the yellow of fields and the yellow of fences, the ultramarine of rivers swollen by rain and the violet-blue of seas in which whirlpools are forming and the sky is mirrored, and he loves gold and silver ✪

Hundertwasser's painting technique, like his use of colour, is open to the influence of nature ✪ He paints with water-colours and with oils, with gold-dust and brick-dust, with pulverized stones and with earth; from his last trip to Uganda he brought back a piece of an ant-hill ✪ He varnishes with bee's wax and terpentine, with egg-white and resin-varnish ✪

It would certainly be simpler for him to buy oil-colours and canvas in an art-shop , but Hundertwasser has an aversion to ready-made articles ✪ He likes to make everything himself ✪ For him painting begins with the preparation of the bases, and the process of pre-

paration often lasts longer than the
actual painting – gradually and imper-
ceptably these preparations draw him
into the painting itself: out of experi-
mentation and preparation the creative
process is born, out of a game develops
work on an painting, though this work
always remains a light-hearted game 🔧

Hundertwasser prefers to use his own
method of mounting hand-finished
paper on jute or hemp, aiming for a
particularly durable, smooth and
absorbent painting surface; or he
meticulously pastes together used
envelopes or smoothed-out old
wrapping-paper, and as he involves
himself in these activities the painting
to come already has him under its spell 🔧

Cézanne once demanded that a painting
should represent a harmony parallel
to nature. In his painting Hundert-
wasser has fulfilled this dictum in a
far more direct and literal sense than
any artist before him, perhaps even
more literally and humbly than
Cézanne had meant 🔧

In recent years Hundertwasser has
largely abandoned painting in favour
of graphic art in which he has taken
up and modified the themes of his
pictures ⊕ There are several reasons for
this ⊕ One of these is his idea that he
is never really finished with any picture
but continues to dream about it,
constantly inventing new variations ⊕
He would like his works to be owned
not by just a few wealthy collectors
but for it to be possible for practically
anyone to possess a painting by him;
he would like his work to become
known even in the countries farthest
away from Europe, to carry his
message of joy, colour and poetry to
Japan, Australia, New Zealand . . .

New Zealand was never far from
Hundertwasser's mind as he worked
for three years on the fifty colour
variations for his silk-screen print
»Good Morning City«, with its phos-
phorous clouds luminous in the night,
and for a further two years on the ten
prints of the Portfolio »Rainy Day«;
with these prints he wanted to reach

even those distant islands with their paradisiacally peaceful flora and fauna ☺ And now the prints have really found their way at last to Auckland and Wellington ☺

It took a relatively long time for Hundertwasser to be recognized and acknowledged as one of the most important painters of the post-war period, as the great outsider who was to provide the stimulus to new movements in art ☺ On the other hand, his graphic work took only a very short time to win not only the appreciation of connoisseurs but also a broadly-based popularity; it is a highly valued on the art market as the graphic work of Picasso, Miró or Salvador Dali: its success seems without parallel ☺

Finally, a word about the three names with which Hundertwasser signs his paintings and which aptly sum up his personality ☺ All three were chosen by himself ☺ The most recent, »Regentag« (Rainy Day), is the name he gave the ship on which he now lives most of the

time, an old salt-freighter which used to sail between Tunis and Marseille and which he renovated in his own style, painted and equipped with colourful sails ◉ He now likes to call himself »Herr Regentag« or »Captain Regentag« after this ship; it has almost completely absorbed his thoughts in the last few years and he has taken it out on numerous voyages ◉ He decided on the name »Regentag« because »on a rainy day colours begin to shine« and sparkle – »that is why an overcast day – a rainy day – is the kind of day I like best ◉ This is a day on which I can work ◉ When it rains I'm happy …« ◉

»Regentag« is also connected to the element of his first name, the name by which he became famous, »Hundert-wasser« ◉ Originally his name was Friedrich Stowasser ◉ At the age of twenty he had already been painting for a number of year when he learnt that in Slavonic languages the syllable »sto« means »a hundred« – so he trans-formed his name into the poetic »Hundertwasser« ◉ He changed his first

name to »Friedereich«, later to »Friedens-
reich« ◉ During his visit to Japan in the
early 60's his name had to be tran-
scribed into Japanese script which
bases itself on concepts and objects;
»Hundertwasser« presented no diffi-
culties and »Friedrich« was written with
the characters for »peace« (Friede) and
»realm« (Reich) ◉ His first and second
names, »Friedensreich« and »Hundert-
wasser«, each contain exactly the same
number of letters – thirteen ◉ Hundert-
wasser believes in the magic of these
numbers, that they augur good fortune
for him like a favourable sign in the
stars ◉

A trace of superstition is part of the
charm of his pictures, an awareness of
analogies and associations which
transcend the purely pictorial element
and affect his life and the lives of those
who see or possess his works ◉ For this
reason Hundertwasser keeps track of
the whereabouts of each of his pictures ◉
He attaches great importance not only
to their genesis (the date, locality,
when, where and how long he worked
on them and what materials he used)

he can tell many stories about their
histories, about how many times each
has changed hands and homes ᴁ All of
this might seem at first to be merely
peripheral information but it adds an
essential dimension to Hundert-
wasser's pictures ᴁ One could call it the
dimension of life ᴁ And it is precisely
this which is their most unique
characteristic, the key to their under-
standing: that in and through them the
personal, the private, even the intimate
sphere of life is continually being
transformed into something objective
and of universal meaning, into art ᴁ
The technique, the themes, the titles:
everything is determined by this
»person al« quality of his work, is ex-
plained by it and yet reaches beyond it ᴁ
For through the medium of the personal
these pictures guide and entice us
along labyrinthine paths into the depths
of our era, into the mystery of great
painting where much of the psyche of
the painter always lies hidden ᴁ Hundert-
wasser's paintings are full of longing,
at the same time containing within

themselves the fulfilment of this
longing They speak of paradises lost
and they bear witness to a fulfilled life

WIELAND SCHMIED
Kestner Gesellschaft Hannover, 1973

HUNDERTWASSER AUF DEM WEG NA
NEUSEELAND

Die Ausstellung seiner Werke in den
Museen von Neuseeland und Australie
für Hundertwasser von besonderer Be
tung ☺ Unter allen Orten dieser Welt
verkörpert die Vorstellung von Neusee
für ihn ein letztes irdisches Paradies:
bisher von den Deformierungen und d
Hässlichkeit der Zivilisation unberührt
Ort; unberührt auch von der Überindu
alisierung der westlichen Welt, die and
orts verschmutztes Wasser, vergiftete
geschädigte Wälder mit sich brachte;
einen Ort, der noch nicht den Niederga
guter Handwerkskunst und der Wert-
schätzung der Leistung des Einzelnen
erlebt und ebenso wenig die Krankhei
der menschlichen Psyche erfahren hat
die in gleichem Maß zunehmen, wie di
Geschosse moderner Wolkenkratzer ☺

Somit bietet Neuseeland ihm anschein
die Möglichkeit eines noch im Wesentl
natürlichen Lebens, und für Hundertw

ist ein natürliches Leben gleichbedeutend mit einem kreativen Leben ℗

Neuseeland verkörpert für ihn seine Utopie einer gesunden, harmonischen Existenz, die jedem Individuum die Gelegenheit bietet, seine natürlichen Begabungen zu entdecken und sie in einer sinnvollen, uneingeschränkten Weise zu entwickeln ℗

Die Vorstellung von Neuseeland als einem Land mit unverdorbener Natur hat Hundertwassers Malerei beeinflusst ℗ Wenn er malt, träumt er von ewig grünen Inseln des Friedens ℗ Je mehr in den letzten Jahren Umweltverschmutzung und die Plünderung urzeitlicher Naturreichtümer der Erde zunahmen, desto wichtiger wurde für Hundertwasser sein Bild einer Weltgegend, wo diese Phänomene noch unbekannt sind ℗

So kam es, dass Hundertwasser sich in seiner Malerei schon lange auf dem Weg in dieses Land befindet: Anlässlich dieser Ausstellung wird sich jetzt sein Traum erfüllen, es in der Realität zu erleben ℗ Wenn nämlich er selbst und sein Werk von den Menschen in Neuseeland als zu ihnen

gehörig akzeptiert würden, wäre das für
ihn von größerer Bedeutung als jeder
Erfolg in den großen Zentren der Kunstwelt
in New York, London oder Paris, gleich wie
spektakulär ❦

Bei Hundertwassers Vision einer
menschlich-natürlichen Welt, erträumt
von einem »Maler reinen Herzens« (wie
er schon früh genannt wurde), handelt es
sich keineswegs um ein nachrangiges
Interesse, das den Maler nur oberflächlich
beschäftigt ❦ Sie ist im Gegenteil ein
zentrales Anliegen seines Werkes, ist
sowohl Quelle als auch Ziel seines künst-
lerischen Schaffens; sie beherrscht sein
Denken und Handeln, ebenso wie sie
Gehalt, Form, Farbe und Technik seiner
Malerei bestimmt ❦

Gegenstand von Hundertwassers Bildern
sind labyrinthische Architekturen, von
schützenden Zäunen umgebene hügel-
gleiche Häuser, haushohe Dampfschiffe
umringt von schützenden Wellen, blatt-
artige Fenster umgeben von schützenden
Spiralen, die sich unter zahlreichen
Windungen nach Innen drehen, wie Pfade,
die in eine sichere Höhle führen ❦

Auf den Dächern seiner Bauten, häufig Hochhäuser, bei denen die Geschosse auseinander wachsen, schief, von Regen triefend und verwittert, sprießt Gras, wachsen Bäume und Wiesen, ist die Natur zurückgekehrt. Die Natur als Gebäude, Landschaft als Gebäude, der Berg als Gebäude, der Baum als Gebäude: dies ist eines der grundlegenden Motive von Hundertwassers Malerei ❀ Die Forderungen, die Hundertwasser immer wieder nachdrücklich in seinen Architekturmanifesten stellte, in denen es ihm um eine individuelle, vielgestaltige, unangepasste Architektur geht, kam von Beginn an im Geist seiner Bilder zum Ausdruck.

Selbst die einzelnen Formen seiner Bilder sind organisch determiniert – Konstruktionen wie die gerade Linie und der rechte Winkel sind ihnen fremd ❀ Hundertwassers Formen wurzeln in der Fülle eines üppigen Barock, sind hergeleitet vom ornamentalen Reichtum des Jugendstils, einer Kunstrichtung, die sich immer auf lebende Formen und folglich auf die Natur berief ❀ Im Jugendstil waren es die stilisierten Wellen, die langen, empfindsa-

men Schwingungen, die es ihm angetan
hatten, sowie ihre Ursprünge in den vielen
verschiedenen Bildern des Wachsens, von
Algen, Lianen, Binsen, kriechenden Pflan-
zen und Wasserlilien, die ihm gefielen 🌀
Die einem organischen Bauplan folgenden
einzelnen Linien und Farbstreifen ver-
schmelzen zu unregelmäßig gebogenen
Formen, Allegorien pflanzlichen Lebens 🌀

Hundertwassers Lieblingsfarbe ist Grün.
Grün, behauptet er, sollte überall sein:
auf Wiesen und auf Dächern, im Wasser
und auf Bergen. Sein Auge kann die
verschiedensten Schattierungen von Grün
wahrnehmen, von Schweinfurter Grün bis
zum Grün von Schimmel und Grünspan 🌀
Gras ist grün und Inseln sind grün, das
Blattwerk von Bäumen und Regenfluten,
Augen und Wolken können grün sein,
Teiche und Fenster, der Bart eines kahlköp-
figen Mannes und der Kopf des dreiäugigen
Buddha, der indische Dschungel und
venezianische Blumen, der Little Palace of
Disease und die Three Houses of Atlantis,
seine Dampfschiffe und seine Spiralen 🌀
Außer Grün liebt er das Braun von Pozzu-
oli-Erde und das Ocker von gebranntem

Siena, das Gelb der Felder und das Gelb
der Zäune, das Ultramarin der vom Regen
angeschwollenen Flüsse und das Blauvio-
lett von Meeren, in denen sich Strudel
bilden und der Himmel sich spiegelt, und
er liebt Gold und Silber ❧

Wie die Wahl seiner Farben ist auch
Hundertwassers Maltechnik offen für den
Einfluss der Natur ❧ Er malt mit Wasser-
und mit Ölfarben, mit Gold- und Ziegel-
staub, mit pulverisierten Steinen und
mit Erde; von seiner letzten Reise
nach Uganda brachte er ein Stück eines
Ameisenhügels mit ❧ Zum Firnissen
verwendet er Bienenwachs und Terpentin,
Eiweiß und Harz ❧

Es wäre gewiss einfacher für ihn, Ölfarben
und Leinwand beim Künstlerbedarf zu
besorgen, aber Hundertwasser sind
gebrauchsfertige Produkte ein Gräuel. Er
macht gerne alles selbst ❧ Für ihn fängt
das Malen mit der Herstellung der Grundie-
rungen an, und dieser Prozess dauert
häufig länger, als das eigentliche Malen –
allmählich und unmerklich ziehen ihn die
Zubereitungen in das Malen selbst hinein:
aus Experimentieren und Vorbereiten

entsteht der kreative Prozess, aus spielerischem Tun entwickelt sich Arbeit an einem Gemälde, wenngleich diese Arbeit stets ein unbeschwertes Spiel bleibt 💧 Hundertwasser zieht bevorzugt nach seiner eigenen Methode von Hand satiniertes Papier auf Jute oder Hanf auf, um eine besonders langlebige glatte und saugfähige Malfläche zu erhalten: oder er klebt akribisch benutzte Briefumschläge oder geglättetes altes Geschenkpapier zusammen, und noch während er sich in diese Tätigkeiten vertieft, hat ihn das kommende Bild schon in seinen Bann gezogen 💧

Cézanne forderte einmal, ein Gemälde müsse eine der Natur entsprechende Harmonie verkörpern. Mit seiner Malerei entspricht Hundertwasser diesem Diktum in einem weit unmittelbareren und buchstäblicheren Sinn als irgendein Künstler vor ihm, vielleicht sogar buchstäblicher und bescheidener, als Cézanne es meinte 💧

In jüngster Zeit hat Hundertwasser die Malerei weitgehend aufgegeben und sich der Grafik zugewandt, in der er Themen seiner Bilder aufgreift und abwandelt 💧

Dafür gibt es mehrere Gründe ☺ Einer davon ist seine Vorstellung, mit keinem Bild wirklich fertig zu sein, sondern sich weiterhin damit zu beschäftigen und ständig neue Variationen zu erfinden ☺ Er sähe es gerne, wenn seine Gemälde sich nicht im Besitz einiger wohlhabender Sammler befänden, sondern wenn praktisch jedermann eines seiner Bilder besitzen könnte; es gefiele ihm, wenn sein Werk selbst in den von Europa an weitesten entfernt liegenden Ländern bekannt würde und seine Botschaft von Freude, Farbe und Poesie nach Japan, Australien und Neuseeland trüge.

Während der drei Jahre, die Hundertwasser an den fünfzig Farbvariationen für seinen Siebdruck »Good Morning City« mit seinen bei Nacht leuchtenden, phosphoreszierenden Wolken arbeitete, drehten sich seine Gedanken häufig um Neuseeland, und ebenso während weiterer zwei Jahre bei der Arbeit an den zehn Blättern der Mappe »Rainy Day«: mit diesen Blättern wollte er sogar diese fernen Inseln mit ihrer paradiesisch friedvollen Flora und Fauna erreichen ☺ Und jetzt sind die Blätter zumindest in Auckland und Wellington

wirklich angekommen. Es dauerte relativ lange, ehe Hundertwasser als einer der wichtigsten Maler der Nachkriegszeit anerkannt und gewürdigt wurde, als der große Außenseiter, dessen grafisches Werk die Kunst zu neuen Bewegungen stimulierte ❦ Andererseits brauchte sein grafisches Werk nur sehr kurze Zeit, um nicht nur von Kennern geschätzt zu werden, sondern auch zu verbreiteter Popularität zu gelangen; auf dem Kunstmarkt ist es ebenso hoch bewertet wie das grafische Werk Picassos, Mirós oder Salvador Dalís: Sein Erfolg erscheint beispiellos ❦

Abschließend ein Wort zu den drei Namen, mit denen Hundertwasser seine Gemälde signiert und die seine Persönlichkeit treffend erfassen ❦ Alle drei sind von ihm selbst gewählt ❦ Der jüngste, »Regentag«, ist der Name, auf den er das Schiff taufte, auf dem er heute die meiste Zeit lebt, ein alter Salzfrachter, der zwischen Tunis und Marseille verkehrte und den er in seinem typischen Stil renovierte, bemalte und mit bunten Segeln ausstattete ❦ Er nennt sich jetzt gern nach seinem Schiff »Herr Regentag« oder »Captain Regentag«; in letzter Zeit beschäftigt ihn dieses Schiff sehr, und

…r hat damit viele Seereisen unternommen ◎ Er entschied sich für »Regentag«, weil »an einem Regentag beginnen die Farben zu leuchten« – »Deswegen ist ein trüber Tag – ein Regentag – für mich der schönste Tag ◎ Das ist ein Tag, an dem ich arbeiten kann ◎ Wenn es regnet, bin ich glücklich …«◎

»Regentag« ist darüber hinaus mit dem Element seines ersten Namens verbunden, dem Namen, mit dem er berühmt wurde: »Hundertwasser«. Ursprünglich hieß er Friedrich Stowasser ◎ Im Alter von zwanzig erfuhr er, dass in slawischen Sprachen die Silbe »sto« »hundert« bedeutet – also wandelte er seinen Namen zum poetischen »Hundertwasser« um ◎ Er veränderte seinen Vornamen zu »Friede-reich«, später »Friedensreich« ◎ Während eines Besuchs in Japan zu Beginn der 60er Jahre musste sein Name in japanische Schrift transkribiert werden, die auf Begriffen und Objekten beruht; »Hundertwasser« bereitete keine Schwierig-keiten und »Friedrich« wurde mit dem Zeichen für »Friede« und »Reich« geschrie-ben. Sein Vor- und Nachname bestehen jeweils aus der gleichen Zahl von Buch-

staben, nämlich dreizehn ☺ Hundert-
wasser glaubt an die Magie dieser Zahlen,
die ihm Glück verheißen, ähnlich wie ein
günstiges Sternzeichen ☺ Eine Spur
Aberglaube macht einen Teil des Charmes
seiner Bilder aus, die Kenntnis von
Analogien und Assoziationen, die über die
rein bildliche Grundlage hinausgehen und
sein Leben sowie das derjenigen, die seine
Werke sehen oder besitzen, beeinflussen.
Aus diesem Grund verfolgt Hundertwasser
den Verbleib jedes seiner Bilder ☺ Er
misst nicht nur ihrer Genese große Bedeu-
tung bei (Datum, Ort, wann, wo und wie
lange er an ihnen arbeitete und welche
Materialien er verwendete), sondern auch
ihrem anschließenden Geschick: Er kann
viele Geschichten über ihren jeweiligen
Werdegang erzählen, darüber wie häufig
ihr Besitzer und ihr Standort wechselte ☺
All dies mag auf den ersten Blick wie
Information von peripherer Bedeutung
erscheinen, aber es ergänzt Hundert-
wassers Bilder um eine wesentliche
Dimension ☺ Man könnte sie die Dimen-
sion des Lebens nennen ☺ Und genau dies
ist ihre Eigenschaft, der Schlüssel zu ihrem
Verständnis: dass sich in ihnen und durch

sie die persönliche, private, ja die intime
Sphäre des Lebens unablässig in etwas
objektives, etwas von universeller Bedeu-
tung wandelt, in Kunst ◎ Die Technik, die
Themen, die Titel: Alles wird von dieser
»persönlichen« Eigenart seines Werks
bestimmt, wird durch sie erklärt und greift
doch über sie hinaus ◎ Denn durch das
Medium des Persönlichen führen uns diese
Bilder und leiten uns entlang gewundener
Wege in die Tiefen unseres Zeitalters, in
das Mysterium großer Malerei, wo viel
von der Seele des Malers stets verborgen
liegt ◎ Hundertwassers Bilder sind erfüllt
von Sehnsucht, während sie in sich
gleichzeitig die Erfüllung seines Sehnens
enthalten ◎ Sie erzählen von verlorenen
Paradiesen und zeugen von einem erfüllten
Leben ◎

WIELAND SCHMIED
Kestner Gesellschaft Hannover, 1973

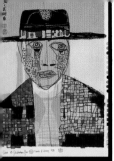

90 A
St. Mandé 1950, Vienna-Tokyo 1974

**THE TEARS OF AN ARTIST
NAKU GEIJITSUKA
57 x 42,5 cm (44,5 x 31,2)
Portfolio "MIDORI NO NAMIDA"
Total signed edition 200
Japanese woodcut in 25 colours
Coordinator David Kung
Cut by K. Okura, Tokyo
Printed by M. Uchigawa, Tokyo
Published by Gruener Janura, Glarus**

Working proof

132
Vienna 1951

**ART CLUB ROTAPRINT PORTFOLIO
30 x 21 cm
Edition 100 signed and numbered only on
introduction sheet
9 rotaprint lithographies in 1 to 3 colours
Published by the Art Club Dr. Schmeller
Cover of Art Club portfolio with house (black)**

Not exhibited

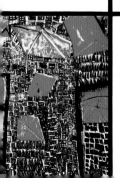

I City from above
(black and vermilion)

II **Skyscraper with trees**
 (black, green and red)

III **Girl with eyeglasses**
 (green, blue and red)

IV **Girl and boy with house and bird**
 (black, blue and green)

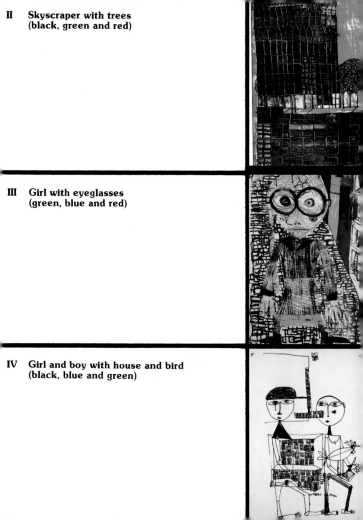

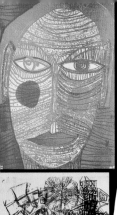

V The face
(carmine and vermilion)

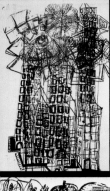

VI High house with trees
(black and blue-green)

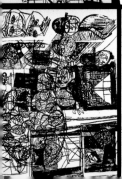

VII Faces looking out of windows
(black)

VIII Singing steamers
 (red, blue and green)

 Not included in most portfolios

IX Cyclist in the rain
 (dark-blue, light-blue and green)

 Not included in most portfolios

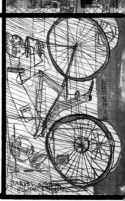

X Garden
 (red, green)

 Not included in the portfolio because
 Hundertwasser considered this print too
 faulty

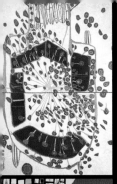

153 A

AUTOMOBIL WITH RED RAINDROPS
61,5 x 87,5 cm
Signed edition 101 and 9 proofs
Lithography in many colours with vertical
red cloth stripe through the middle
Printed by Mourlot, Paris
Published by Dokumenta III, Kassel 1964

Specimen 96/101

155

Vienna 1953

THREE HIGH HOUSES
72 x 55 cm (61 x 44)
Edition 60 and 10 proofs all signed
Linol cut in 3 colours: blue, yellow and red
Published by Moderne Galerie, Salzburg
Gustav H. Beck and Slavi Soucek

Specimen 8/60

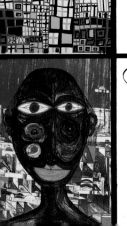

221

Zurich 1955

ARABIAN WOMAN
49,5 x 39 cm
Edition 100 and 25 proofs all signed
Lithography in red, green, brown and blue
to violet
Printed and published by ARTA GROSSEN-
BACHER, Zurich 1955

Proof X

305 Paris 1957

FRESHLY FOUND LABYRINTH
62 x 46 cm (51 x 45)
Exhibition poster for the Galerie H. Kamer
Edition 50 not signed
Lithography in red and green on brown egg
tempera splash applied with a knife by the
artist
Published by Kamer, Paris 1957

Specimen not signed and not numbered

368 A Lengmoos 1971

EYEBALANCE NUMBER FIVE
67 x 50 cm (63 x 47)
Portfolio "REGENTAG"
Entire edition 3000,
300 numbers ending with "1" are signed
Silkscreen in 26 colours with metal imprints
in 4 colours
Printed by Dietz Offizin, Lengmoos
in cooperation with Günter Dietz
Published by Ars Viva, Zurich

Not signed specimen 152/3000

414 Paris 1959

THE FLIGHT OF THE DALAI LAMA
56 x 59 cm (60 x 75 entire version not cut
with white bord)
Edition about 1800 not numbered. About
500 were signed later
Lithography in 2 versions: vermilion,
orange, green (red version), red, green,
blue (blue version) divided and glued together
horizontally für the DALAI LAMA edition of
"PANDERMA" 28 x 118 cm (cut version)
Printed by Patris, Paris 1959
Published by Carl Laszlo, Panderma,
Basle 1959

Entire specimen of the red version

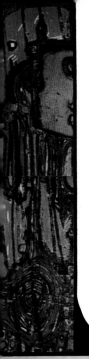

THE FLIGHT OF THE DALAI LAMA
28 x 118 cm
Horizontally divided specimen of the blue
version

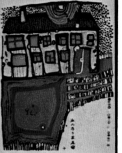

463 A **Niederösterreich 1961, Tokyo 1974**

BLOOD GARDEN HOUSE
CHI NO ARU KATEI
54 x 43 cm (47,5 x 37)
Edition 200 all signed
Japanese wood cut in 20 colours
Cut by Hideo Maruyama
Printed by T. Matsuoka, Kyoto
Coordinator Yuuko Ikewada
Published by Gruener Janura, Glarus

Specimen 61/200

470 A

Venice-Tokyo 1971

RELATIONS OF A SPIDER
KUMO NO KANKEI
32 x 24 cm (30 x 23)
Portfolio "NANA HYAKU MIZU"
Edition 200 all signed
Japanese wood cut in about 20 colours
Cut and printed by Nakamura Hanga
Kobo, Tokyo
Coordinator Yuuko Ikewada
Published by Gruener Janura, Glarus

Specimen 18/200

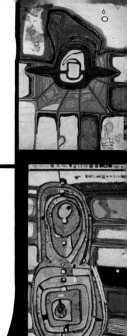

473 A

Tokyo 1961-Tokyo 1972

TWO CLOUDS RAINING 7 COLOURS
NANASHUKU NI HENBO SURU FUTATSU
NO KUMO
42 x 57 cm (29 x 51)
Portfolio "MIDORI NO NAMIDA"
Edition 200 all signed
Japanese wood cut in about 20 colours
Cut by K. Okura
Printed by M. Uchikawa, Tokyo
Coordinator David Kúng
Published by Gruener Janura, Glarus

Specimen 1/200

475 A

Venice-Kyoto 1972

RAIN OF BLOOD IS FALLING INTO THE
GARDEN CHI NO AMAMIZU NO NIWA
40 x 56 cm (40 x 50)
Portfolio "NANA HYAKU MIZU"
Edition 200 all signed
Japanese wood cut in about 20 colours
Cut by Hideo Maruyama
Printed by T. Matsuoka, Kyoto
Coordinator Yuuko Ikewada
Published by Gruener Janura, Glarus

Specimen 18/200

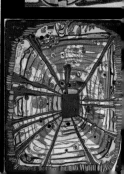

484 A
Tokyo 1961

HOUSES IN RAIN OF BLOOD
40 x 53,5 cm (39 x 52)
Edition 100 signed and numbered, 5 proofs
Japanese wood cut in about 20 colours
Cut by K. Okura
Printed by Studio Adachi, Tokyo
Published by Samuel Dubiner, Ramat-Gan,
Israel 1961

Specimen 36/100

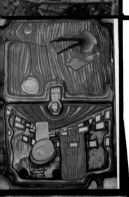

487 A
Venice-Tokyo 1970

LITTLE PALACE OF ILLNESS
CHIISANA SHIRO NO BI NO BYOIN
37 x 26 cm (35 x 24)
Portfolio "NANA HYAKU MIZU"
Edition 100 all signed
Japanese wood cut in about 20 colours
Cut and printed by
Nakamura Hanga Kobo, Tokyo 1970
Coordinator Yuuko Ikewada
Published by Gruener Janura, Glarus

Specimen 18/200

522
Milan 1962

THE HOUSE LOOKS AT A BURNING MAN
26 x 19,5 cm (14,5 x 11)
Edition 100 all signed,
60 for the portfolio book,
XXV for collaborators, 15 hors commerce
Etching in black
Printed by G. Leblanc, Paris
Published by Galleria Schwarz, Milan 1962,
for the portfolio book "L'Avanguardia
Internazionale IV"

Artist proof

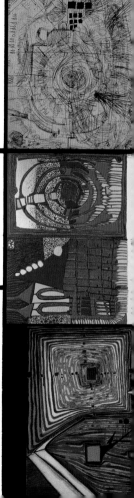

529
Paris 1957-1959, Vienna 1962

SPIRAL WITH NEUFFER HEADS
38 x 28,5 cm
Head up right and nude up left by
Hans Neuffer
Signed edition 50, some proofs without
NEUFFER drawing
Etching in black and white
Printed by G. Leblanc, Paris
Published by Enrico Magalio de Micheli,
Paris 1962

Artist proof

540
Venice 1962

HOUSE AND SPIRAL IN THE RAIN
35 x 50 cm (25 x 33)
Signed edition 102
Lithography in red, green, blue and yellow
Printed and published by
Edizione del Cavallino Renato Cardazzo,
Venice 1962

Specimen 84/102

551 A
Venice-Tokyo 1967

**SPIRAL SUN AND MOON HOUSE —
THE NEIGHBOURS
TAIYOO NO RINOIN TO TSUKI NO IE**
35 x 53 cm (33 x 50)
Portfolio "NANA HYAKU MIZU"
Edition 200 all signed
Japanese wood cut in about 20 colours
Cut and printed by Nakamura Hanga
Kobo, Tokyo 1967
Coordinator Yuuko Ikewada
Published by Gruener Janura, Glarus

Specimen 18/200

553 A

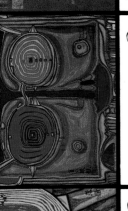

STREET FOR SURVIVORS
67 x 50 cm (63 x 42)
Portfolio "REGENTAG"
Entire edition 3000,
300 numberes ending with "2" are signed
Silkscreen in 16 colours with metal
imprints in 3 colours and one
phosphorescent colour on grey paper
Printed by Dietz Offizin, Lengmoos
in cooperation with Günter Dietz
Published by Ars Viva, Zurich

Signed specimen 152/3000

563 A

Venice-Tokyo 1968

SPECTACLES IN THE SMALL FACE
MEKURA NO MEGAME
35 x 43 cm (33 x 41)
Portfolio "NANA HYAKU MIZU"
Edition 200 all signed
Japanese wood cut in about 20 colours
Cut and printed by Nakamura Hanga
Kobo, Tokyo 1968
Coordinator Yuuko Ikewada
Published by Gruener Janura, Glarus

Specimen 18/200

603 A

Venice-Tokyo 1966

SUNSET
RAKU YOO
26 x 34 cm (25 x 33)
Portfolio "NANA HYAKU MIZU"
Edition 200 all signed
Japanese wood cut in about 20 colours
Cut and printed by Nakamura Hanga
Kobo, Tokyo 1966
Coordinator Yuuko Ikewada
Published by Gruener Janura, Glarus

Specimen 18/200

607
Hanover 1964

GIRL FINDING IN THE GRASS
41 x 53 cm (20 x 28)
Edition 300 and 50 proofs all signed
about 5 more not signed proofs turned
up later
Etching in dark green
Yellow, red and pink in offset
Published by Kestner Gesellschaft
Dr. Wieland Schmied, Hannover

Specimen XXX

630 A
Lengmoos 1971

**IT HURTS TO WAIT WITH LOVE
IF LOVE IS SOMEWHERE ELSE**
67 x 50 cm (61 x 40)
Portfolio "REGENTAG"
Entire edition 3000,
300 numbers ending with "3" are signed
Silkscreen in 27 colours with metal imprints
in 6 colours and 2 phosphorescent colours
Printed by Dietz Offizin, Lengmoos
in cooperation with Günter Dietz
Published by Ars Viva, Zurich

Not signed specimen 152/3000

637 A
Venice-Tokyo 1969

**WAITING HOUSES
MATTE IRU IE**
32 x 42 cm (30 x 40)
Portfolio "NANA HYAKU MIZU"
Edition 200 all signed
Japanese wood cut in about 20 colours
Cut and printed by Nakamura Hanga
Kobo, Tokyo
Coordinator Yuuko Ikewada
Published by Gruener Janura, Glarus

Specimen 18/200

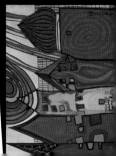

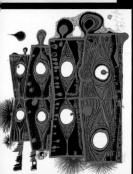

THE EYES OF MACCHU PICCHU
50 x 66 cm (47 x 56)
Yellow edition 132 all signed
33 (66) more specimens of both versions ?
have been used for collages on the numbered
Macchu Picchu box book multiple 638 I
Text by Pablo Neruda
Yellow version: yellow, blue, green and red
Lithography in 4 colours an 2 colour versions
Printed by Michel Casse, Paris 1966
Published by Claude Givaudan S.A., Geneva

Specimen 99/132

(638) Paris 1966

THE EYES OF MACCHU PICCHU
50 x 66 cm (47 x 56)
Black edition 132 all signed
Black version: black, blue, green and red
Lithography in 4 colours and 2 colour
versions
Printed by Michel Casse, Paris 1966
Published by Claude Givaudan S.A., Geneva

Specimen 127/132

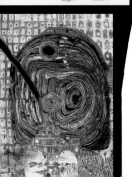

(639) old number (633) Giudecca-
 Sardinia-Paris 1966

THE JOURNEY I
Transformation of 4 colour separation plates
reproducing (344) Nostalgie de l'au delà
57 x 38 cm (32 x 24) grand marge
39,5 x 29 cm (32 x 24) general size
Entire edition about 280
Signed edition 107 (50+14+25+18)
150 not signed specimens for the book
PAROLES PEINTES III
19 more specimens were found later from
which the artist signed 11
Etching from 4 copper plates in yellow, red,
green and blue
Printed by Lacourière, Capelle,
and Jacques David, Paris
Published by Lazar-Vernet, Paris 1967

Specimen 2/18 (105/107)

650 A

Lengmoos 1971

EXODUS INTO SPACE
67 x 50 cm (63 x 45)
Portfolio "REGENTAG"
Entire edition 3000,
300 numbers ending with "4" are signed
Silkscreen in 28 colours with metal imprints
in 4 colours and 2 phosphorescent colours
Printed by Dietz Offizin, Lengmoos
in cooperation with Günter Dietz
Published by Ars Viva, Zurich

Not signed specimen 152/3000

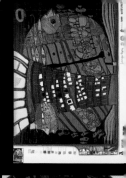

652

Paris 1967

JOURNEY II AND TRAVEL BY RAIL
65,5 x 50 cm
Edition 267 and 5 proofs all signed
Lithography in 5 colours: yellow, green,
red, black and blue
2 colours versions: black or blue portholes
Printed by Michel Casse, Paris
Published by Galerie Krugier and Moos,
Geneva 1969
Version with black portholes

Specimen 266/267

653

Paris 1967

THE BOY WITH THE GREEN HAIR
After painting (635) Ma již nečteré
snalosti češtiny
64 x 37 cm (52 x 37)
Edition 100 and 50 proofs (HC) all signed
Furthermore 600 Galerie Flinker exhibition
posters not signed
Lithography in many colours
Printed by Mourlot, Paris
in cooperation with Serge
Published by Galerie Flinker, Paris 1967

Specimen HC 47/50

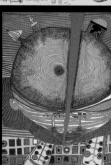

655

THE ENDLESS WAY TO YOU
After painting (626) Der Weg zu Dir
52 x 62 cm (44 x 53)
Edition 100 and 50 proofs (HC) all signed
Lithography in many colours
Printed by Mourlot, Paris
in cooperation with "Serge"
Published by Galerie Flinker, Paris

Specimen HC 37/50 (150)

Paris 196

656

THE EXPULSION
After Painting (634) Marta
71 x 90 cm (68 x 80)
Edition 154 all signed
Furthermore 700 Galerie Krugier and Galeri
Moos exhibition posters not signed
Lithography in many colours
Printed by Mourlot, Paris
in cooperation with "Serge"
Published by Krugier and Moos, Geneva 1967

Specimen 132/154

Paris 196

658

THE FALSE EYELASH
After painting (654) The Trip
71 x 50 cm (62 x 49)
Edition 181
143-155 do not exist
Numbers 1-100/100 and 101-194/194 all signe
Lithography in many colours
Printed by Mourlot, Paris
in cooperation with "Serge"
Published by the Hannover Gallery, London

Specimen 44/194

659 A

Zwolle 1967-Rakino Island-Venice 1973

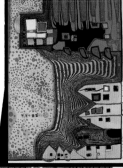

FLOODED SLEEP
KOZUI NO SUIMIN
43 x 57 cm (36 x 50,5)
Portfolio "MIDORI NO NAMIDA"
Total signed edition 200
About 10 artist specimen not signed
Japanese woodcut in 33 colours
Coordinator David Kung
Cut by K. Okura, Tokyo
Printed by M. Uchikawa, Tokyo
Published by Gruener Janura, Glarus

Working proof

660

Paris 1967

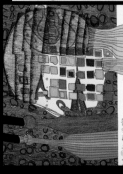

SHADOW OF THE STARS
After Painting (657) The night of the
drinking woman
52 x 61 cm (42 x 53)
Edition 150 all signed
Furthermore 150 Kunstverein Berlin
exhibition posters not signed
Lithography in many colours
Printed by Mourlot, Paris
in cooperation with "Serge"
Published by Krugier and Moos, Geneva 1967

Specimen 111/150

668

Rome 1967

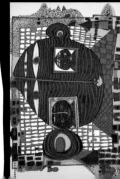

GOOD BYE FROM AFRICA
50 x 70 cm (48 x 62)
Edition 160 and 17 proofs all signed
Lithography in 6 colours with gold and silver
imprints
2 colour versions: gold windows, silver, blue,
red, yellow and turquoise
and: silver windows, gold, light blue, siena,
red, yellow and turquoise
Printed by Alberto Caprini
in cooperation with Günter Dietz
Published by Galleria Medusa, Rome

Gold window version
Specimen 32/90 (CLX)

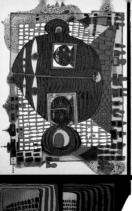

Rome 1967

GOOD BYE FROM AFRICA
Printed by Dietz Offizin, Lengmoos
in cooperation with Günter Dietz

Siver window version
Specimen 37/70 (CLX)

669

Venice 1968

KING KONG
After painting (202) Head with 2
perspectives
65 x 49 cm (62 x 47)
Edition 115 and 16 proofs all signed
Silkscreen in 19 colours and gold and
silver imprints
Coordinator Alberto Della Vecchia
Metal imprints by Verrati, Mestre
Printed and published by Galleria Elefante,
Venice 1968

Specimen 96/115

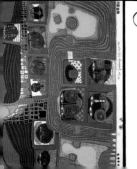

675

Lipari Island 1968

KINGDOM OF THE TOROS
After painting (665) On the red roads of
the mountains of the moon
52 x 69 cm (44 x 60)
Signed edition 170 and about 10 proofs
Silkscreen in 9 colours and gold and silver
imprints
Coordinator Alberto Della Vecchia
Metal imprints by Verrati, Mestre
Printed and published by Galleria Elefante,
Venice 1968

Specimen 27/170

676 A
Lengmoos 1971

A RAINY DAY ON THE REGENTAG
67 x 48 (64 x 45)
Portfolio "REGENTAG"
Entire edition 3000,
300 numbers ending with "5" are signed
Silkscreen in 16 colours with metal imprints
in 5 colours on metallic cardboard
Printed by Dietz Offizin, Lengmoos
in cooperation with Günter Dietz
Published by Ars Viva, Zurich

Not signed specimen 157/3000

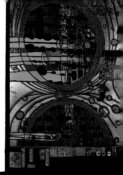

680
Venice-Berkeley 1968-1970

SAD NOT SO SAD IS RAINSHINE
FROM RAINDAY ON A RAINY DAY
After painting (285) The announcement
74 x 56 cm (70 x 50)
Edition 250 and 25 proofs all signed
6 colour versions
Silkscreen in 10 colours and 2 metal imprints
Printed by Galleria Elefante, Venice
Published by University Art Museum, Berkeley 1968
111 specimens were overprinted with 5 more
colours and gold imprint by Studio Quattro,
Venice-Mestre and Alberto Della Vecchia
Overprinted specimen 144/250

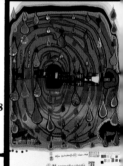

683
Mendocino 1968-La Vallesina 1969

LA BARCA-REGENTAG
SLOW TRAVEL UNDER THE SUN
After painting (677) La Barca Regentag.
Slow travel under the sun of Calabria
76 x 56 cm (71 x 52)
Edition 251 and 26 proofs all signed
6 colour versions (A-F)
Silkscreen in 10 colours with metal imprints
in 7 colours
Coordinator Alberto Della Vecchia
Printed by Studio Quattro, Venice-Mestre 1969
Metal imprints by Verrati, Mestre
Published by Felix Landau, Los Angeles

Specimen A/24/251

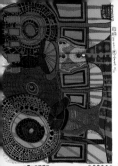

Giudecca-Campalto 1968-1969

A RAINY DAY WITH WALTER KAMPMANN
After painting (612) Good day Mr. Kampmann
52 x 70 cm (42 x 61)
Edition 170 and 45 proofs all signed
8 colours versions
Silkscreen in 12 colours with metal imprints
in 5 colours
Coordinator Alberto Della Vecchia
Printed by Studio Quattro, Venice-Mestre
Metal imprints by Verrati, Mestre
Published by Ugo Meneghini, Venice 1969

Specimen E.A. XXIII/XXXXV

Giudecca 1969–1970

686 **GOOD MORNING CITY** 85 x 55,5 cm
After painting (151) Bleeding houses
Entire edition 10 000 all signed
This is one of the normal edition of
8000 copies divided into 40 different colour
versions of 200 specimens each, namely:
B-C-D-E-G-H-I-J-L-M-N-O-Q-R-S-T-W-X-Y-Z
BB-CC-DD-EE-GG-HH-II-JJ-LL-MM-NN-OO-
QQ-RR-SS-TT-WW-XX-YY-ZZ
Silkscreen in 10 colours with metal imprints in 8 col
Coordinator Alberto Della Vecchia
Printed by Studio Quattro,Venice-Mestre 1969-1970
Published by Dorothea Leonhart, Munich

Specimen J 6993/10 000

686 **Giudecca 1970**

GOOD MORNING CITY
BLEEDING TOWN
85 x 55,5 cm Entire edition 10 000 all signed
This is one of the phosphorescent edition of
2000 copies divided into 10 different colour
versions series of 200 each, namely:
A-F-K-P-U-AA-FF-KK-PP-UU
Each series divided into 4 variations of
50 specimens
Silkscreen in 16 colours with 2 phosphorescent
colours and metal imprints in 10 colours
Coordinator Alberto Della Vecchia
Printed by Studio Quattro, Venice-Mestre 1970
Published by Ars Viva, Zurich 1971

Phosphor version specimen A 149/10 000

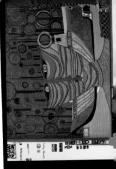

687 A
Lengmoos 1971

COLUMBUS RAINY DAY IN INDIA
67 x 49 cm (65 x 46)
Portfolio "REGENTAG"
Entire edition 3000,
300 numbers ending with "6" are signed
Silkscreen in 17 colours with metal imprints
in 5 colours
Printed by Dietz Offizin, Lengmoos
in cooperation with Günter Dietz
Published by Ars Viva, Zurich

Not signed specimen 152/3000

688 A
Paris-Campalto 1969, Venice-Tokyo 1971

TWO TREES ON BOARD OF REGENTAG
AME NO HI MARU NO NIHON NO KI
43 x 54 cm (37 x 51)
Portfolio "MIDORI NO NAMIDA"
Edition 200 and 26 proofs all signed
Japanese wood cut in 38 colours
Coordinator David Kung
Cut by K. Okura, Tokyo
Printed by M. Uchikawa, Tokyo
Published by Gruener Janura, Glarus

Proof XIV/XXVI

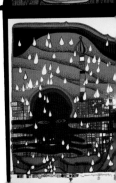

690
Venice 1970-1972

GREEN POWER
After painting (625) Winterpainting
83 x 64 cm (77 x 58)
Edition 249 and 36 proofs all signed
Silkscreen in 19 colours with metal imprints
in 2 colours and 2 phosphorescent colours
Coordinator Alberto Della Vecchia
Printed by Serialgraphic, Venice
Metal imprints by Studio Quattro, Mestre
Published by Gruener Janura, Glarus

Specimen 24/249

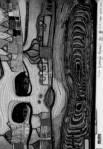

691 A Lengmoos 1971

IRINALAND OVER THE BALCANS
67 x 49 cm (62 x 44)
Portfolio "REGENTAG"
Entire edition 3000,
300 numbers ending with "7" are signed
Silkscreen in 29 colours with metal imprints
in 5 colours and 2 phosphorescent colours
Printed by Dietz Offizin, Lengmoos
in cooperation with Günter Dietz
Published by Ars Viva, Zurich

Not signed specimen 152/3000

692 A Rom-Venice 1969, Tokyo 1972

THE RAIN FALLS FAR FROM US
HARUSAME WA KANATUNI
43 x 54 cm (37 x 51)
Portfolio "MIDORI NO NAMIDA"
Edition 200
Japanese wood cut in 31 colours
Coordinator David Kung
Cut by K. Okura, Tokyo
Printed by M. Uchigawa, Tokyo
Published by Gruener Janura, Glarus

Working proof

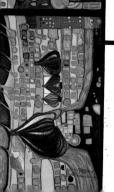

696 A Giudecca 1971

YELLOW LAST WILL
52,5 x 74,5 cm
Edition 475 all signed
Silkscreen in 22 colours a nt
printed on silver foil mou rd
Printed by Dietz Offizin,
in cooperation with Günte
Published by Schünemann

Specimen 425/475

REGENTAG ON WAVES OF LOVE
67 x 49 cm (64 x 43)
Portfolio "REGENTAG"
Entire edition 3000,
300 numbers ending with "8" are signed
Silkscreen in 23 colours with metal imprints
in 3 colours and one glass-perl-reflection
layer
Printed by Dietz Offizin, Lengmoos
in cooperation with Günter Dietz
Published by Ars Viva, Zurich

Not signed specimen 152/3000

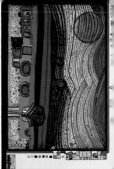

**THE HOUSES ARE HANGING
UNDERNEATH THE MEADOWS**
67 x 49 cm (60 x 46)
Portfolio "REGENTAG"
Entire edition 3000,
300 numbers ending with "9" are signed
Silkscreen in 19 colours with metal imprints
in 3 colours
Printed by Dietz Offizin, Lengmoos
in cooperation with Günter Dietz
Published by Ars Viva, Zurich

Not signed specimen 152/3000

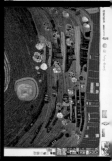

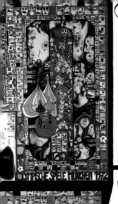

OLYMPIC GAMES MUNICH 1972
Painting after ⟨147⟩ Match of the Century
110 x 69 cm (104 x 65)
First signed stage
Edition 200 and 20 proofs all signed
Silkscreen in 21 colours with metal imprints
in 5 colours and one velvet layer on white paper
Many colour variations
Printed by Dietz Offizin, Lengmoos
in cooperation with Günter Dietz
Published by Edition Olympia 1972
GmbH, Munich

Specimen 199/200

OLYMPIC GAMES MUNICH 1972
102 x 64 cm
Second not signed poster stage
Numbered edition 3999, about 200 proofs
not signed
Silkscreen in 22 colours and metal imprints
in 5 colours on brown tar package paper
Many colour variations
Printed by Dietz Offizin, Lengmoos
in cooperation with Günter Dietz
Published by Edition Olympia 1972
GmbH, Munich

Poster stage specimen 3715/3999

CRUSADE OF THE CROSSROADERS
67 x 49 cm (60 x 44)
Portfolio "REGENTAG"
Entire edition 3000,
300 numbers ending with "0" are signed
Silkscreen in 17 colours with metal imprints
in 7 colours and one glass-perl-reflection
layer on brown tar package paper
Two versions: black center and red center
Printed by Dietz Offizin, Lengmoos
in cooperation with Günter Dietz
Published by Ars Viva, Zurich

Not signed specimen 152/3000

(712) After silkscreen Munich 1972
(691A) Irinaland und 702 III Regentag-Stempel

Poster for the film by Peter Schamoni
"HUNDERTWASSER'S RAINY DAY"
98 x 68 cm
Not signed edition of 800 posters
marked: without commercial value
Silkscreen in many colours
Printed by Dietz Offizin, Lengmoos

Not signed specimen

(715) Cannes 1972

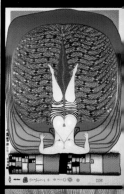

HOMMAGE TO SCHRÖDER-SONNENSTERN
After painting by Sonnenstern "Eva (Praxis)"
100 x 70 cm (93 x 65)
First signed stage: edition 420 from which
only 416 are signed
Silkscreen in 8 colours and metal imprints in
4 colours with one velvet layer on white paper

Second not signed poster stage:
numbered edition 4200

Silkscreen in 8 colours with metal imprints in
4 colours on grey-brown paper with gold
imprinted signature
Printed by Dietz Offizin, Lengmoos
in cooperation with Günter Dietz
Published by Ars Viva, Zurich

Specimen 386/416

(728) Vienna 1974

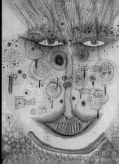

MEADOWMAN
66 x 55 cm (32 x 24,5)
Edition 240 and 40 proofs all signed
Aquatint coloured etching from 3 copper plates
in 3 colour variations of 80 specimens each:
Softbrown, softblue, deep blue
Printed by Robert Finger, Vienna
Published by Gruener Janura, Glarus
for the Albertina, Vienna

Specimen 3/240

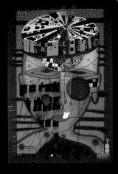

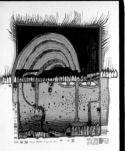

ONE OF FIVE SEAMEN – IL MARINAIO
After painting **678** The Sailor
90 x 60 cm
Edition 250 and 87 proofs all signed
in 5 versions, namely:
 0- 50 African black paper
 51-100 European white paper
101-150 Red Indian brown paper
151-200 Chinese Yellowbrown paper
201-250 Astroaustralian grey paper

Silkscreen in 18 colours
with metal imprints in 2 colours
Coordinator Alberto Della Vecchia
Printed by Serialgraphic Venice
Metal Imprints Studio Quatro, Mestre
Published by Gruener Janura, Glarus
for Aberbach Fine Art on the
occasion of the U.S.A. Graphic tour

Specimen 1/240

BURNING WINTER
76 x 58,5 cm
Edition 227 and XXX proofs all
signed and numbered:
green sky 1- 75
black sky 76-147
red sky 148-227
Silkscreen in 17 colours with
metal imprints in two colours:
Metal Windows:

Green	Blue
1- 37	38- 75
76-113	114-147
148-186	187-227
XIII-XXX	Green Tears

Coordinator: Alberto Della Vecchia
Printed by Studio Quattro, Mestre
Published by Gruener Janura, Glarus

Specimen 188/227

BIOGRAPHICAL NOTES

1928 Born in Vienna, 15th December
 (name: Friedrich Stowasser)

1929 Father dies

1934 First youthful drawings

1936 Enters Montessori School, Vienna.
 Report emphasizes an
 »unusual sense of colour and from«

1943 Makes the first conscious crayon drawings
 from nature. In this year 69 of his
 Jewish maternal relatives are deported to
 Eastern Europe and killed

1948 School-leaving certificate. Spends three
 months at the Academy of Fine Arts, Vienna;
 is influenced by Egon Schiele.
 An exhibition by Walter Kampmann, painter of
 transparent glass trees, in the Graphische
 Sammlung Albertina, Vienna, leaves a powerful
 impression.
 His own style begins to develop

1949 Chooses the name »Hundertwasser«.
 Travels in Tuscany with the painter René Brô.
 Is impressed by pottery tiles in Liquescent
 colours in a little café in Rome.
 Is influenced by Paul Klee

1950 First stay in Paris. Leaves the Ecole des
 Beaux-Arts on the first day. Paints two
 murals together with Brô in Saint Mandé.
 Stays seven years with family Dumage in
 St. Mandé as their guest.
 Friendship with Shinkichi Tajiri

1951 Travels in Marocco and Tunis. Takes a liking
 to Arab music. Joins the Art-Club, Vienna,
 in September 1951

1952 Decorative and abstract phase. First
 One-man-show in Vienna at the »Art Club«

1953 The first spiral appears in his painting,
 Stuttgart June.
 Second stay in Paris.
 Works in Brô's studio in Saint Maurice
 alone during the summer

1954 First exhibition in Paris at Studio Paul
 Facchetti in January.

Spends September and October in the Santo
Spirito hospital in Rome with jaundice. Paints
numerous water-colours during this period.
Hundertwasser evolves the theory of »Transauto-
matism« and begins to number his paintings

1955 Exhibition in the Galleria del Naviglio, Milan

1956 In the summer he joins the crew of an
 Estonian ship sailing under the Liberian flag
 from Söderhamn to Hull.
 Studies the individual visual association
 process in the observer of a picture.
 Writes: Cinéma Individuel Transautomatique.
 Publishes »La visibilité de la création
 transautomatique« in »Cimaise« and »Phases«,
 Paris.
 Friendship with Siegfried Poppe

1957 Buys »La Picaudière«, a rural property in
 Normandy. Develops the theory of »Transauto-
 matism« into a »Grammar of Vision«.
 Is awarded Prix du Syndicat d'Initiative at
 the 1st Biennale, Bordeaux

1957/60 Contract with Galerie H. Kamer, Paris

marriage in Gibraltar (dissolved 1960).
Reads his »Mouldiness Manifesto: Against
Rationalism in Architecture« at a congress
in Kloster Seckau, Austria, and subsequently
in the Galerie van de Loo, Munich, and in
the Galerie Parnass, Wuppertal

1959 Awarded Sanbra Prize at the 5th Biennale,
Sao Paulo. In autumn accepts guest Lectureshi
at the Kunsthochschule, Hamburg. Draws the
»Endless Line«. Meets opposition and is
ordered to interrupt Resigns Lectureship

1960 Organizes the happening »Les Orties« -
how to get independent by living on nettles -
in connection with Alain Jouffroy's
»Antiprocès«. Exhibition at the Raymond
Cordier Gallery, Paris, represented by
Raymond Cordier

1961 Visit to Japan. Awarded Mainichi Prize at
6th International Art Exhibition, Tokyo.
Achieves first major success at the
Tokyo Gallery, Tokyo.
Visits Hokkaido and Siberia

1962 Married to Yuuko Ikewada in Vienna (marriage
dissolved 1966). Studio on the Giudecca, Venice

One-man exhibition in the Austrian pavilion at the Venice Biennale attracts considerable attention

1963 Visits Greece.
Represented by dealer Siegfried Adler

1964 Mountaineering tour in the Tyrolean Alps.
Prepares in Hannover his extensive travelling exhibition, arranged by the Kestner-Gesellschaft, through the museums of Hannover, Amsterdam, Berne, Hagen, Stockholm, Vienna. The Kestner-Gesellschaft publishes his first oeuvre catalogue

1965 Essay on »35 days in Sweden«. Exhibition at Moderna Museet, Stockholm, shows a record of visitors

1966 Unhappiness in Love

1967 Tours Uganda and the Sudan. Takes up graphic work in colour, uses metallic embossed imprints for the first time. Travelling exhibition at galleries in Paris (Flinker), London (Hannover Erica Browsen) Geneva (Krugier-Moos), Berlin.

Nude demonstrations in Munich and Vienna (1968) against antihuman environment and sterile architecture

1968 Reads »Los von Loos« »Individual Building Alteration Law And Architecture Boycott Manifesto« in Vienna.
 Tours Northern California. Produces extensive catalogue for his exhibition at the University of California, Berkeley. Sails from Sicily to Venice in the old wooden ship »San Giuseppe T«

1968/72 Converts this vessel into the »Regentag« in shipyards in the Venice Lagoon

1969 Travelling exhibition visits American museums at Berkeley, Santa Barbara, Houston, Chicago, New York, Washington

1969/71 creates 80 variations for his graphic work »Good Morning City-Bleeding Town« followed by a 5 years long trial in German courts with dealer Leonhard.
 Lives and works on board of »Regentag« in the Lagoon of Venice

1970/72 Co-operates with Peter Schamoni on the film »Hundertwasser's Rainy Day«.

Prepares a portfolio of graphic works:
»Looks at it on a rainy day«

1971 Works on the Munich Olympic poster
1972 Friendship with Joram Harel.
Prepares a TV appearance in »Wünsch Dir
Was« and demonstrates with architectural
models for roof afforestation and
autonomous facades.
Issues manifesto: »Your right to windows –
your duty to the trees«. Sails with »Regentag«
1000 miles around Italy to Elba.
His mother dies

1973 11 years of collaboration with Japanese
wood-cutters result in his first Japanese
wood-cut portfolio »Nana Hyaku Mizu«.
Hundertwasser is the first European painter
to be cut by Japanese masters.
Travel to Cap Verde Islands and New Zealand.
Travel exhibition through museums in
New Zealand: Auckland, New Plymouth,
Wellington, Palmerston North, Christchurch,
Dunedin.
Participates at the »Triennale di Milano«
where 12 TREE-TENANTS were planted
through windows at Via Manzoni.

Issues Letter »Inquil ino Albero«.
Visits New York.
Exhibition at Aberbach Fine Art, New York

1974 Travelling exhibition through museums in
Australia: Melbourne, Canberra, Sidney,
Mornington.
The exhibition »Stowasser 1954 Hundert-
wasser 1974« is shown at the Graphische
Sammlung Albertina, Vienna. Publishes the
complete youth work
»Friedrich Stowasser 1943 - 1949«.
Paints the »Conservation Week« poster for
New Zealand.
Designs the stamp »Spiraltree« for Austria
and presents his concept for the traffic
free zone at the Seilergasse, Vienna.
Sails with »Regentag« to Tunis, Cyprus,
Israel.
Exhibition at Facchetti, Paris.
Visits New Zealand and Australia.
Applies for immigration to New Zealand

1975 Designs portfolio for »Midori No Namida«, his
second Japanese woodcut portfolio

Retrospective exhibition at »Haus der Kunst«, Munich.
Publishes the manifestation »Humus Toilet«.
Preparations for his world travelling exhibition tour »Austria presents Hundertwasser to the continents« which will be shown in 35 cities on 5 continents.
Started at the »Musée d'Art Moderne de la Ville de Paris«, »Musée de L'Etat« Luxemburg, »Musée Cantini« Marseille, »A. S. U. Building« Cairo.
The Albertina Exhibition of his complete Graphic work started a U. S. A. museum tour.
Sails with »Regentag« in the Caribic

1976 The exhibition »Austria presents Hundertwasser to the continents« is shown at the »Tel Aviv Museum«, the »Narodowe Muzeum« Warszawa, the »National Gallery of Iceland« Reykjavik, the »Statens Museum for Kunst« Copenhagen and the »Musée Dynamique« Dakar. Joins »Regentag« in Papeete, Tahiti